Glimpses of Bartow

Steve Rajtar

Charleston · London
The History Press

Published by The History Press
Charleston, SC 29403
www.historypress.net

Copyright © 2008 by Steve Rajtar
All rights reserved

All images courtesy of the Florida Photographic Collection.

First published 2008

Manufactured in the United Kingdom

ISBN 978.1.59629.533.9

Library of Congress Cataloging-in-Publication Data

Rajtar, Steve, 1951-
101 glimpses of Bartow / Steve Rajtar.
p. cm.
Includes bibliographical references.
ISBN 978-1-59629-533-9
1. Bartow (Fla.)--History--Pictorial works. 2. Historic buildings--Florida--Bartow--Pictorial works. 3. Bartow (Fla.)--Buildings, structures, etc.--Pictorial works. 4. Bartow (Fla.)--Social life and customs--Pictorial works. 5. Bartow (Fla.)--Description and travel. I. Title. II. Title: One hundred one glimpses of Bartow. III. Title: One hundred and one glimpses of Bartow.
F319.B29R34 2008
975.9'67--dc22
 2008027635

Notice: The information in this book is true and complete to the best of our knowledge. It is offered without guarantee on the part of the author or The History Press. The author and The History Press disclaim all liability in connection with the use of this book.

All rights reserved. No part of this book may be reproduced or transmitted in any form whatsoever without prior written permission from the publisher except in the case of brief quotations embodied in critical articles and reviews.

Contents

Preface ... 5
A Brief History of Bartow ... 7

People ... 19
Downtown Scenes ... 39
Businesses ... 65
Lodgings ... 87
Schools and Churches ... 107

Bibliography ... 125
About the Author ... 127

Preface

In many ways, Bartow is similar to Orlando. Both are inland cities not located on major waterways. Both began as forts to protect the area from the native population and gradually grew into settlements surrounded by cattle and citrus. Their railroads provided a way for local products to be shipped to market.

Both cities also owe a debt of gratitude to a single man, cattle baron Jacob Summerlin, whose generosity resulted in the two cities becoming county seats. In Orlando, Summerlin loaned $10,000 to prevent Sanford from becoming Orange County's governmental center. Later, his donation of substantial acreage provided a site for the Polk County Courthouse, giving Bartow a huge advantage over other nearby towns.

Jacob Summerlin also donated land for churches and a school, facilitating the growth of Bartow into a medium-sized city of major importance. Although not the largest in Polk County in terms of population, Bartow is the center of county government, a local headquarters for a portion of the

state government and a major shipping point for the mineral phosphate, a key ingredient in the manufacture of fertilizer. Furthermore, despite a reduction in the amount of citrus fruit being grown due to a long series of freezes, Bartow remains an important center for that industry.

Today's Bartow is different from other Florida cities of its size and larger in that it lacks theme parks and other attractions to draw tourists. The chamber of commerce has as its goals the promotion of business and economic development as opposed to short-term stays in hotels and facilities designed to thrill and entertain. The local museum focuses on the area's history and, in addition to a very good public library, there is also one that limits its scope to preserving the history and genealogy of the area.

While other parts of Central Florida, including other cities in Polk County, advertise and attempt to attract visitors for the short term, Bartow has a longer vision. It looks back to the beginning of settlement of the area in an attempt to preserve the architecture and culture of the past, while at the same time looking ahead toward long-term economic growth. Its schools have produced state and national leaders, and Bartow is the leader of a growing county destined to play important roles in the future of the region and the state.

A Brief History of Bartow

At the end of the Second Seminole War (1835–42), much of Florida became a prime area for settlement as a result of the Armed Occupation Act of 1842. A man or a family could homestead up to 160 acres of land and receive a deed to it after living there, working the land and defending it from the native population for five years. Although the soil was favorable for agriculture in the vicinity of the Peace River (also known as the Peas River or Peas Creek), that area was excluded from the operation of the new law because it was considered to be the home of the Seminoles.

Even though the land was not entirely free, it attained desirability as the cattlemen of the Tampa area began pushing eastward. A major 1848 hurricane prompted some residents along the coast to consider living farther inland. The earliest permanent settlers moved to the Bartow area in 1851 from Columbia County, Florida. Readding Blount and Elizabeth Varn Blount brought their family, including son Riley R. Blount with his wife and four children; son Owen R. Blount with his wife and two children; son Nathan S.; and daughter

Mary with her husband, Streaty Parker, and two children. With them came about a dozen slaves. John Davidson and his family also arrived at about the same time.

Riley and his wife, Jane, purchased a squatter's hut near Peas Creek that had been built by Captain James D. Green, plus the surrounding 160 acres, for a total price of forty dollars. In 1853, Riley's home was converted into Fort Blount to protect the settlers. It was a blockhouse, with a first floor of about thirty feet square and a second floor that projected out from that about four feet on all sides. It provided a safe place for the settlers during the Third Seminole War of 1855 to 1858 (also known as the Billy Bowlegs War). The fort, located west of today's courthouse, was also used during the Civil War by the Florida Volunteers militia unit.

In 1858, Riley moved a little farther south to a new home. He built a one-room log schoolhouse that year, and Daniel Waldron taught the first class of thirty-four students. Quarterly tuition was four dollars, and monthly board and washing cost six dollars. Riley established a store and carriage manufacturing business and sold his homestead in 1862 to Jacob Summerlin.

Polk County was formed from Hillsborough and Brevard Counties, and it is believed that it was Readding Blount who proposed to name it after James K. Polk, who had been president at the time Florida became a state. Polk became a county on February 8, 1861, after Florida seceded from the Union and while it was technically a free and independent

nation. A matter of days later, Florida aligned with the Confederate States of America.

It was not intended that Bartow would serve as the county seat. For a time, governmental business took place at Mud Lake, Homeland and other locations. An election of area residents held on October 17, 1861, chose the to-be-built planned community of Jefferson to serve in that capacity. Jefferson would have centered around the intersection of Shumate Drive and Clower Street, south of downtown Bartow. However, the Civil War got in the way, plans were changed and Jefferson was never developed as a separate town.

At the outbreak of the Civil War, the community of Fort Blount organized a seventy-nine-man company of militia captained by W.B. Varn. After it reorganized under Nathan S. Blount in 1862, the company marched to Gainesville and joined the Confederate army as Company E of the Seventh Florida Regiment. It fought as part of the Army of Tennessee from April 1862 until April 1865.

Jacob Summerlin acquired the fort buildings and sold them in 1865 to William T. Carpenter, who opened a general store. From 1866 until 1869, that store served as the settlement's unofficial post office. The International Ocean Telegraph line was built in 1866 and opened an office in town.

In 1867, Summerlin donated 120 of his acres to the county: 40 for governmental use, 20 for the construction of a Methodist church, 20 for a Baptist church and 40 as

A Brief History of Bartow

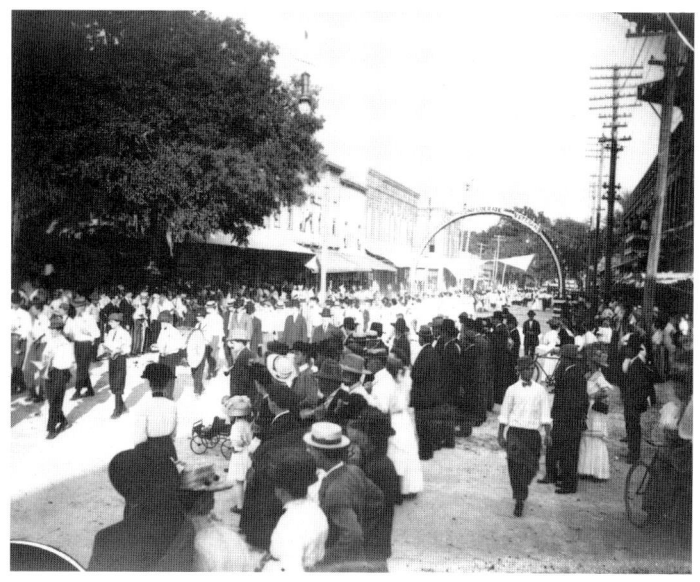

Confederate Veterans
The participation of Bartow's citizens in the Confederate army was celebrated by gatherings of veterans, including this event in 1910.

a school site. The land that he donated for the government ensured the town's designation as the county seat, and the town was platted with a large central square surrounding the courthouse. The first Polk County Courthouse was built by John McAuley of Fort Meade in 1867, costing $3,800.

Also in 1867, at the suggestion of Reverend Robert N. Pylant, the community was named for a Civil War hero,

General Francis Stebbins Bartow of Chatham County, Georgia. He died on July 21, 1861, at the First Battle of Manassas (also known as the First Battle of Bull Run), making him the first Confederate brigade commander to be killed in the war. The Federal government refused to recognize a town named after a Confederate hero and left the official name of the post office as Peas Creek or Peace Creek until 1879.

During the late 1860s, William Carpenter constructed a new hotel and store just to the west of the courthouse. It was built of wood prepared by a sawmill that Jacob Summerlin purchased in St. Augustine and then hauled to Carpenter's Pond by oxen. The store took up an entire city block and was later owned by G.W. Smith. Fire destroyed it in 1905.

Another early merchant was Captain David Hughes, who arrived in Bartow in 1868. He sold goods from a portion of his residence and also engaged in the business of raising cattle for sale. At about the same time, F.F. Beville opened a drugstore.

Bartow's first newspaper appeared in 1881, when D.W.D. Boully of Blountsville, Alabama, founded the *Informant*. At the time, the population of Bartow was only about a hundred and there were few businesses to advertise. However, the early issues of the *Informant* were full of advertisements for Alabama clients who had contracted with Boully before he moved to Florida and had prepaid for columns of space.

The four-page, six-column newspaper urged Bartow residents to patronize shops in Blountsville, while residents

of that town (who still received the newspaper) could read about happenings hundreds of miles away in Bartow. Boully retired from journalism in 1884 and the newspaper was continued by Judge G.A. Hanson and G.M. Holder. In 1888, the *Informant* merged with the *Advance-Courier* to form the *Courier-Informant*.

Also in 1881, the Polk County Immigration Society was established with the goal of promoting the area for settlement and business. That organization fizzled out, but another was started with a similar goal, the Bartow Board of Trade, which appeared in 1887. It later became known as the Bartow Chamber of Commerce.

A meeting of the area citizens was called on May 3, 1882, to discuss the possibility of incorporating the town. It was chaired by David Hughes, and those present were in favor of incorporation. The precise boundaries of the new town had not yet been determined, so a committee consisting of W.H. Pearce, F.F. Beville and J.H. Humphries was given that task, as well as the task of setting up an election. That election was held on July 1, 1882. Twenty-two of the twenty-eight eligible legal voters showed up, incorporated the town and elected J.H. Humphries as its first mayor. Humphries resigned in September to relocate to Virginia. Also in 1882, the new town was connected to Tampa by a stagecoach line, which did three round trips a week.

Because of the donation of land by Jacob Summerlin, the first two churches built in Bartow were the Baptist and the

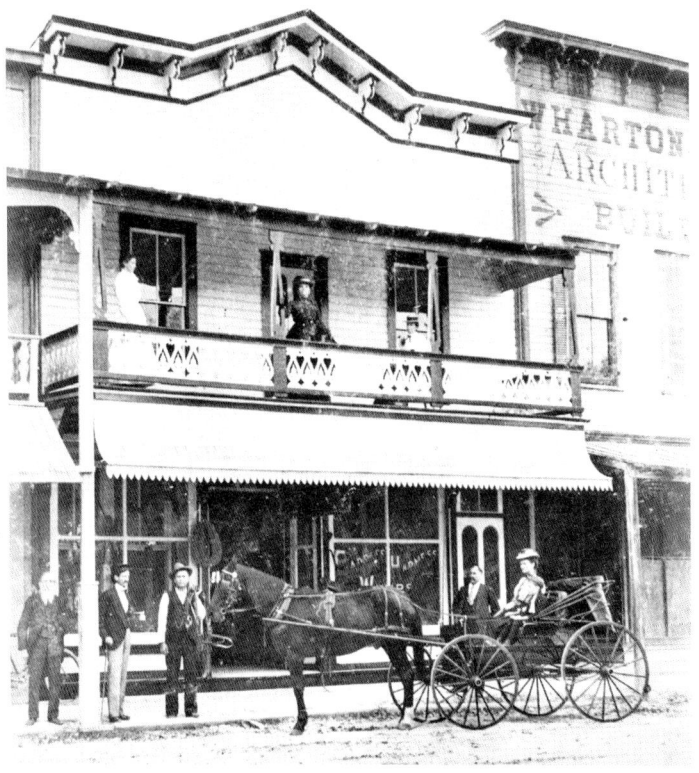

Downtown Bartow
Nineteenth-century Bartow featured dirt roads lined with wooden stores and other businesses, such as those shown here.

Methodist. The Methodist church building was completed first on West Church Street and was dedicated on March 9, 1883. The Baptist sanctuary followed on April 1.

The second courthouse was erected in 1883–84 at a cost of $9,000. That one was torn down in 1912, after governmental functions had already been transferred to the new, third courthouse.

Henry B. Plant's Florida Southern Railway began serving Bartow on January 25, 1885. A depot for handling both passengers and freight was built later that year. The railroad's Charlotte Harbor Division continued on through Arcadia to terminate at the settlement of Trabue on the south side of Charlotte Harbor, seventy-three miles from Bartow.

The Polk County Bank opened in Bartow in 1886, with Frank W. Page as its president. At the time, it claimed to be the bank located the farthest south in the state of Florida. It became a national bank in 1888, the same year that the yellow fever epidemic caused Bartow to halt travel into the city, including trains carrying mail.

Bartow moved into its first city hall in July 1887. It was a two-story wooden building, with the volunteer fire department headquartered downstairs. The city hall sat at the end of Central Avenue at the intersection with Church Street.

Phosphate was discovered in Polk County in about 1881, but it was not commercially shipped from the area until 1888. An essential ingredient in chemical fertilizers, phosphate was sought by many, and new towns sprang up to

accommodate the workers who were engaged in extracting it from the rivers and land. Existing cities prospered, especially Bartow. By 1893, British investors and others became heavily financially involved in the exploitation of the area's rich phosphate deposits.

General Evander McIvor Law arrived in Bartow in 1893 and opened the South Florida Military Institute (also called the South Florida Military Academy or College). A dozen years later, it merged with several other educational institutions throughout Central Florida to form the University of Florida, a Gainesville school for white males. The Bartow school buildings and land were sold to private individuals.

The year 1894 was a difficult one for Bartow. By then, many of the British phosphate investors had pulled out, largely as a result of decreased interest due to the economic depression, the Panic of 1893. A hurricane in 1894 flooded much of Polk County, which was also hit very hard by a pair of severe freezes that began just after Christmas that year.

The city was served with electricity for lighting for the first time on April 18, 1897, when the new power plant was opened by W.H. Towles. He was also responsible for the city beginning to pump water for individual use.

Bartow welcomed its first telephone exchange in February 1902. The town was served by the Peninsular Telephone Company, which had been founded by William G. Brorein the year before in Tampa. Also in 1902, the Smart Set Club

organized with Mrs. Dexter Summerlin as its president. It later became known as the Bartow Women's Club.

The third county courthouse was built in 1908–09 by Mutual Construction Company of Louisville, Kentucky. The $83,890 building was designed by E.C. Hosford of Eastland, Georgia, in neoclassical style. The north and south entrances were flanked by large Corinthian columns. It was expanded in 1926 by the addition of identical east and west wings

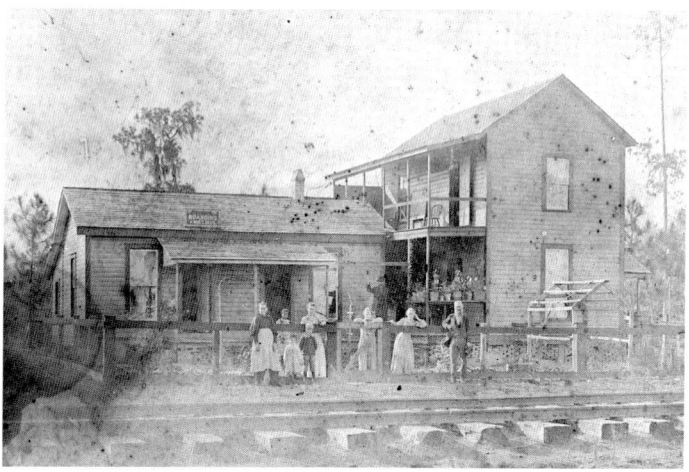

HOTELS
Business travelers and prospective residents often stayed for a time in Bartow's several lodging establishments, such as the Pine Grove Hotel depicted in this photo.

designed by Francis Kennard & Son of Tampa. It still stands on the downtown square, but now has a different use.

In 1911, Andrew Carnegie offered to donate $8,000 toward the construction of a library in Bartow, with the condition that it would not cost the city more than $800 per year to maintain it. Previously, the local library association had housed its books and conducted its meetings in a variety of temporary quarters, and the town desired a permanent home. Logan & Townsend built the new library, which opened on March 16, 1915, with Eunice Coston as its first librarian.

On March 9, 1913, the Seaboard Air Line Railway reached Bartow, and J.E. Windham served as its first local agent. Upon the order of the Railroad Commission, a union station was constructed for the use of both Seaboard and the Atlantic Coast Line Railroads.

In the early 1920s, the Bartow Home Building Company was established to encourage the construction of new homes. Many were built, but in the late 1920s many owners defaulted on their mortgages. The company took back the homes, sold them off and went out of business.

Bartow survived the Great Depression and continued to serve as the county seat, although it was surpassed in population by Lakeland and Winter Haven, both of which offered a more tourist-oriented atmosphere. In 1961, the focus of the entire county was on Bartow when Polk County celebrated its centennial as the thirty-ninth Florida county.

Parades, reenactments and historical displays attracted county residents to Bartow to enjoy the festivities.

The present Polk County Courthouse opened in 1987, and the 1909 courthouse building was turned into a historical museum and library that opened on September 19, 1998. It is part of the Bartow Downtown Commercial District bounded by Davidson and Summerlin Streets and Broadway and Florida Avenues. The district was added to the National Register of Historic Places in 1993.

People

STREATY PARKER
Parker, a Bartow resident, served in the Second Seminole War. He was a captain of the Hickory Boys, a contingent serving at Fort Meade.

101 Glimpses of Historic Bartow

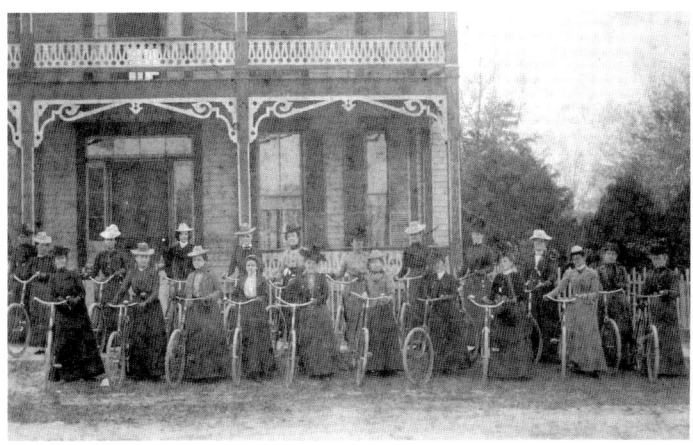

Women with Bicycles
Posed here in the 1880s in front of the Logan house are Bartow women with bicycles. Consider the difficulty of pedaling with ankle-length skirts.

People

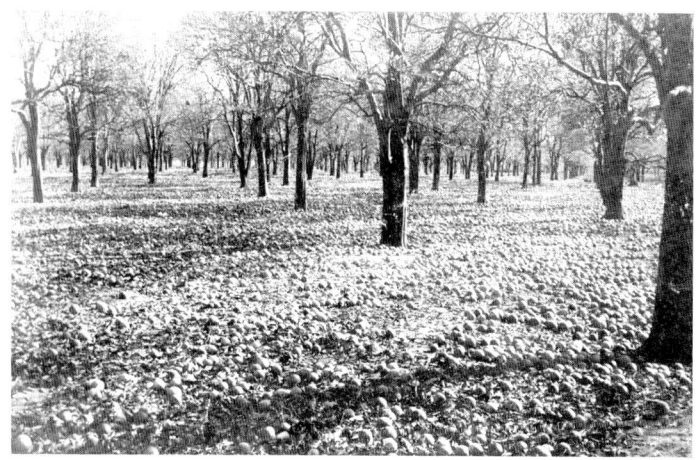

Freeze-Damaged Grove
Freezes in 1894 and early 1895 wiped out most of the local citrus, including this grove previously owned by Streaty Parker. Sap froze inside the trunks.

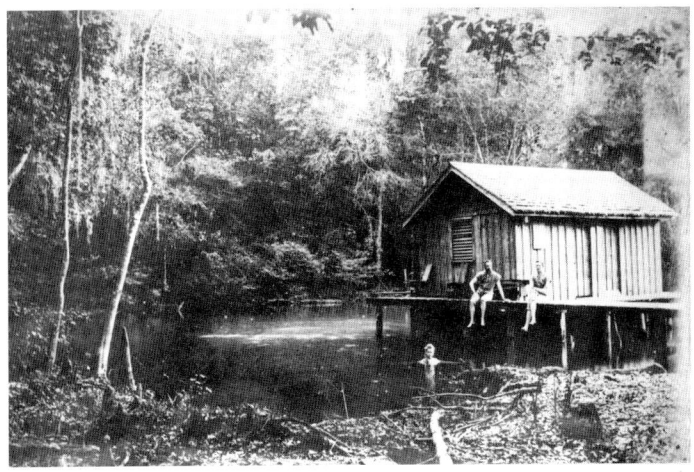

Kissingen Springs
Located near Bartow, this was a popular place to swim and picnic. After this photo was taken in 1894, a pavilion was erected. The springs dried up during the 1950s.

People

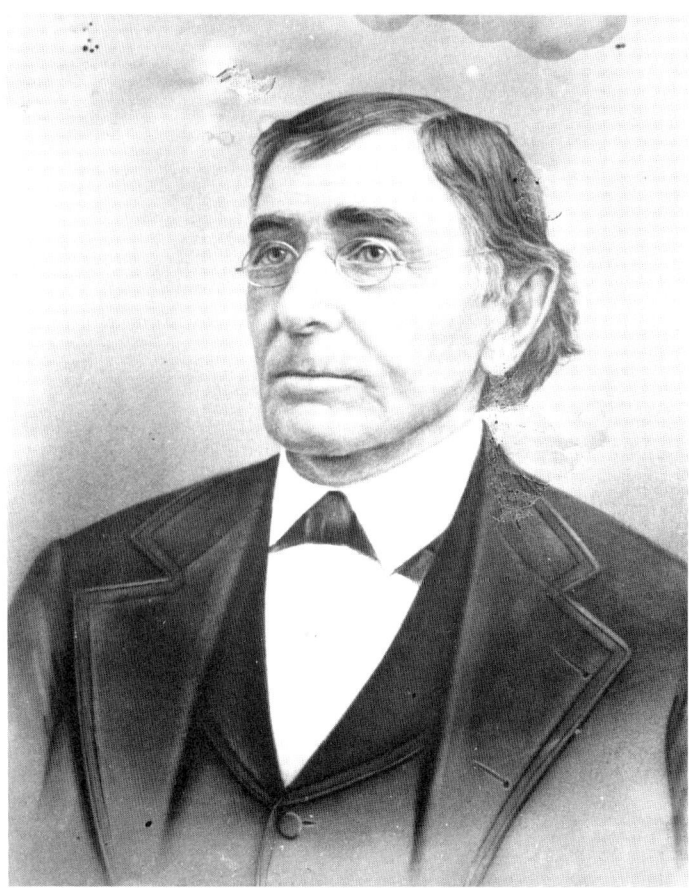

Jacob Summerlin
Cattleman Summerlin's donation of land for the erection of a courthouse in 1867 ensured that Bartow would have the honor of serving as the county seat.

101 Glimpses of Historic Bartow

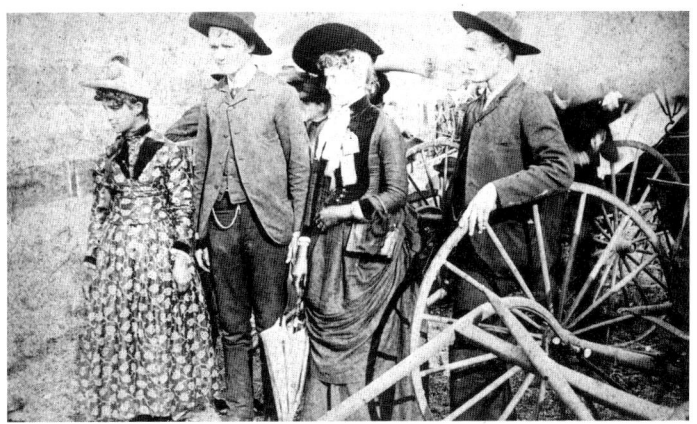

Oak City Guards
A home guard contingent was formed to protect Bartow and become part of the army in times of war. In this image, two members are preparing to leave for training.

People

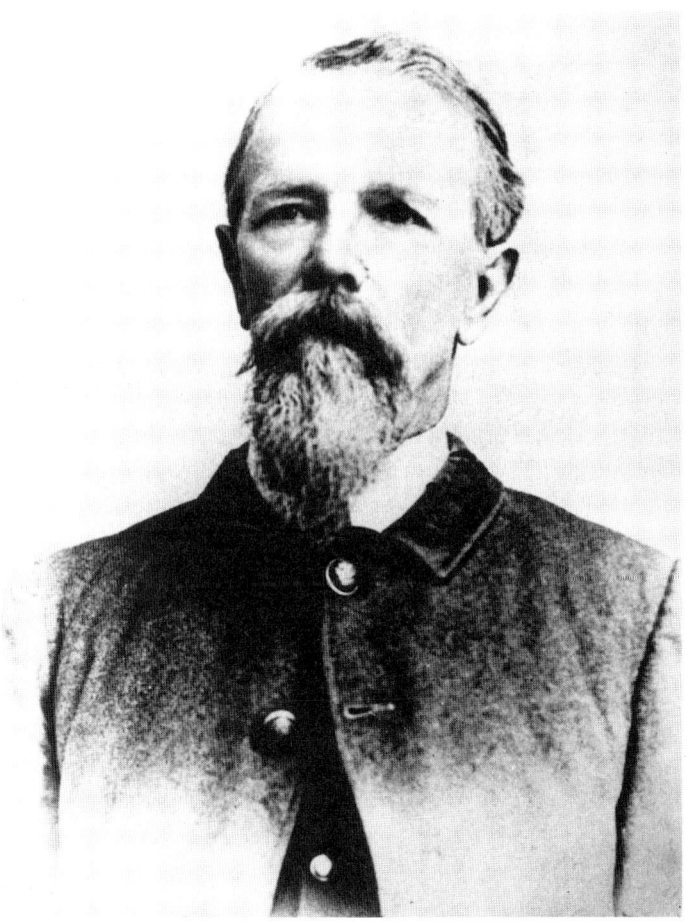

Evander McIvor Law
After serving in the Civil War, Law founded the South Florida Military Institute. He also edited the *Courier-Informant* newspaper for a decade.

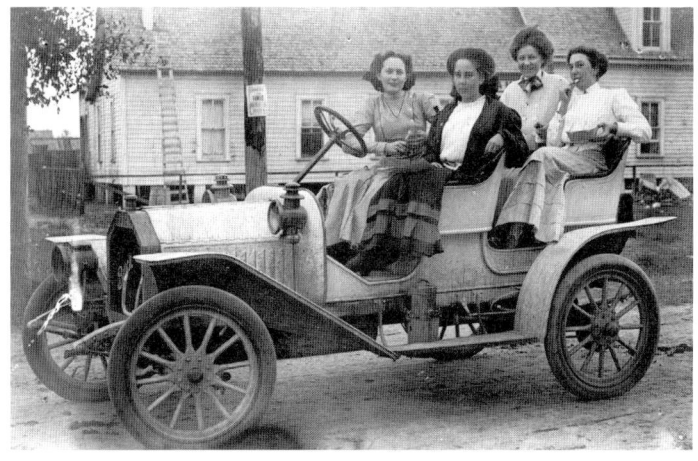

Young Ladies Going for a Drive
In 1905, this Buick was owned by Bartow resident J.W. Sample. Behind the wheel is Sarah Sample, and next to her is Abbie Laura.

People

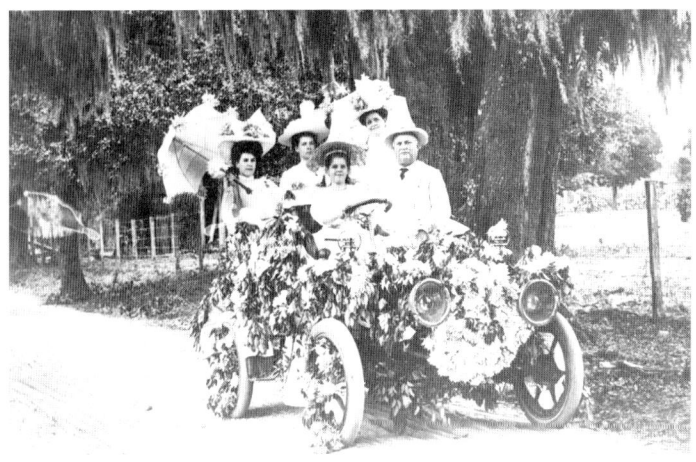

Courthouse Celebration
This parade was held in 1909 to celebrate the completion of the third county courthouse. It was built by a Kentucky contractor for $83,890.

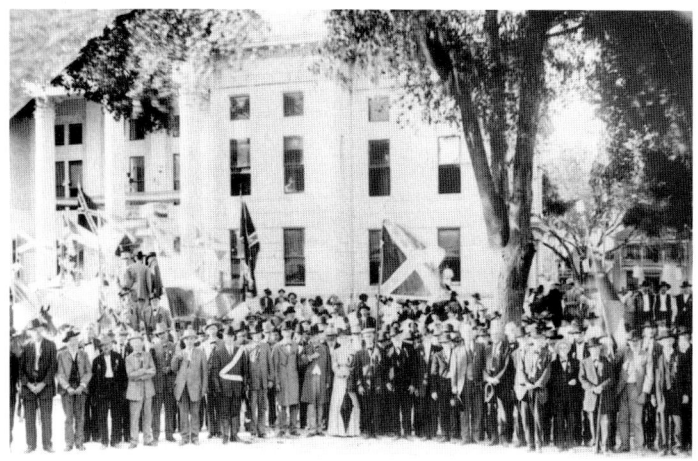

CONFEDERATE REUNION
The entrance to the third county courthouse forms a backdrop for a portrait of Confederate veterans. They held this reunion in Bartow in 1910.

People

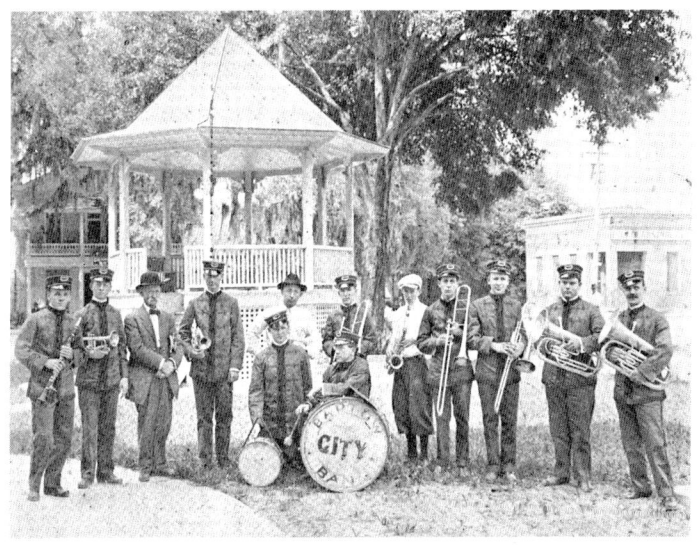

CORNET BAND
The third Bartow Cornet Band poses in front of the bandstand erected in 1914. Behind it are the Commercial Hotel and the Polk County Abstract Company.

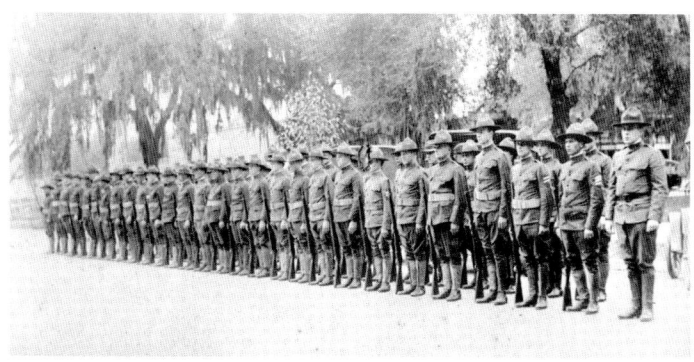

HOME GUARD
The home guard unit was formed to protect Bartow, but it could be called upon in times of war. Shown here in 1918 are its men training for World War I.

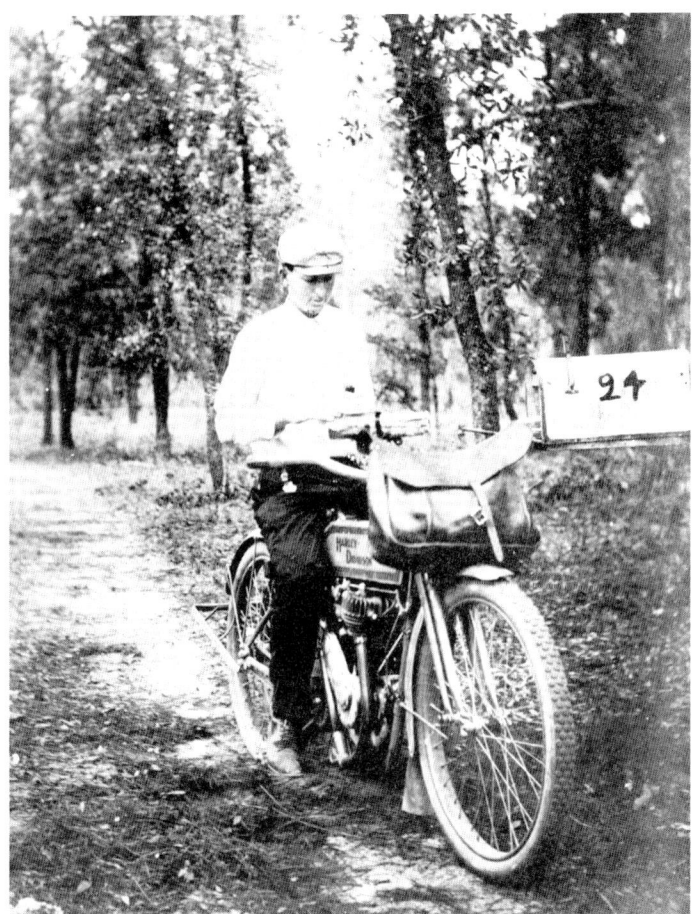

Postman Leon Wingate
Leon Wingate delivered Bartow's mail during the 1920s. He is pictured here in 1927 on his Harley-Davidson motorcycle.

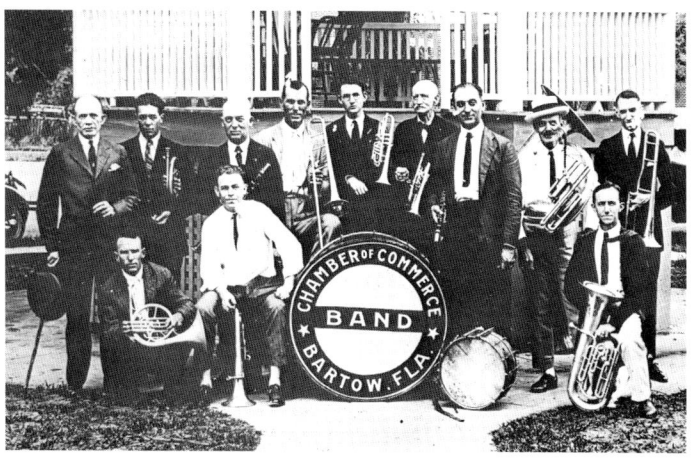

COMMUNITY BAND
Several bands performed for Bartow residents during the 1920s. This one was sponsored by the local chamber of commerce.

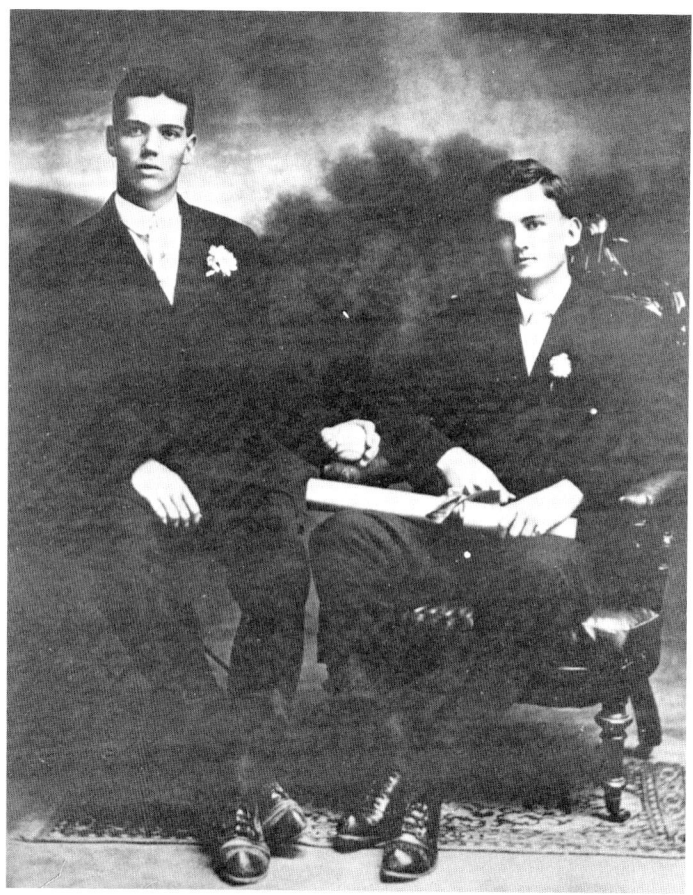

Van Fleet and Holland

On the left is James Van Fleet, who became a four-star general. On the right is Spessard Holland, who became the Florida governor. They were Summerlin Institute classmates.

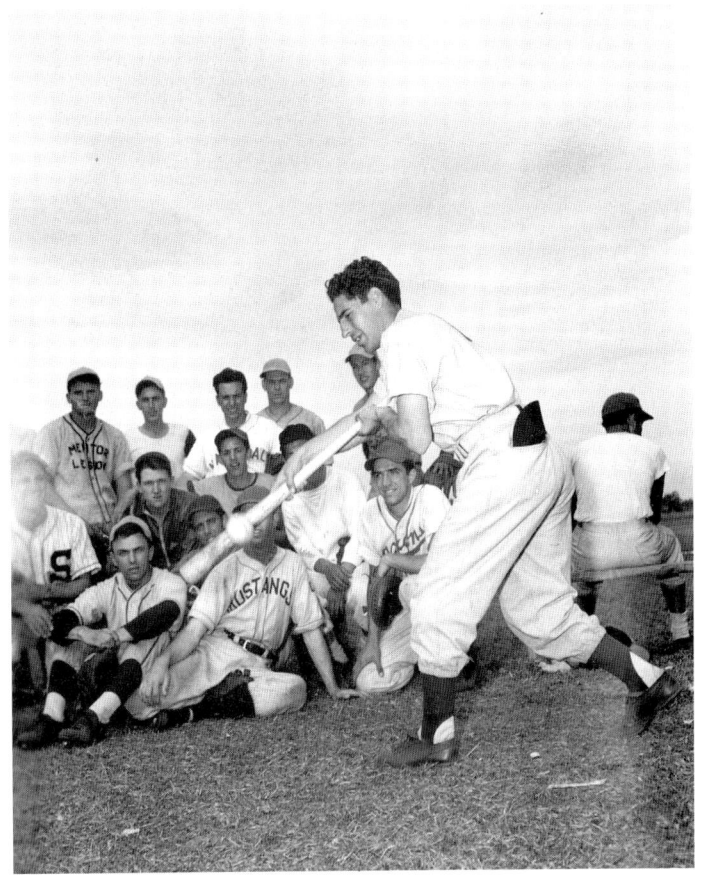

BASEBALL SCHOOL
Yankee Phil Rizzuto demonstrates bunting techniques at a 1948 baseball school operated by Snuffy Stirnweiss and Bob Doty.

People

Spessard Holland
A Bartow native, Holland served as a state senator from 1932 to 1940, as governor from 1941 to 1945 and as a United States senator from 1946 until 1971.

101 Glimpses of Historic Bartow

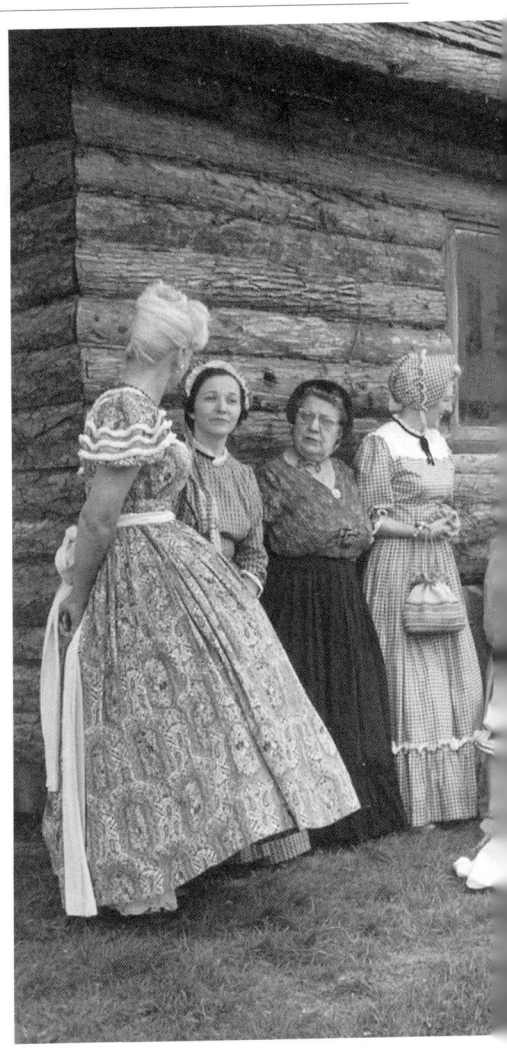

Polk County Centennial

A century after the formation of the county, residents held a festival to celebrate its pioneers. Reenactors appear here in front of a replica of an early cabin.

People

Downtown Scenes

POLK COUNTY COURTHOUSE
The first courthouse, built in 1867, was replaced by this one, erected on land donated by Jacob Summerlin. It was completed in 1884 at a cost of $9,000.

City Hall
In this 1887 building, the city hall was located upstairs and the volunteer fire department downstairs. Bartow's first fire chief was C.E. Reed.

Downtown Scenes

Main Street
Shown here is Main Street shortly after Bartow's first outdoor electric lights were installed in 1897. The building to the left is Gent's Furnishing.

Main Street
Across from the courthouse was this brick block of stores, Bartow's first. The stores were built in 1886 along Main Street.

Downtown Scenes

ELECTRIC PLANT
The city water tower stands just south of the electric light plant, which burned wood to heat boilers. The system became operative in 1897.

CENTRAL AND SUMMERLIN
This corner at Central and Summerlin Avenues was busy in 1910. Later, a new building would be erected here for the Holland & Knight law firm.

Downtown Scenes

POLK COUNTY COURTHOUSE
This neoclassical-style building served as the courthouse for nearly eight decades. In 1998, it became the Polk County Historical Museum.

101 Glimpses of Historic Bartow

Broadway and Church
The tall building in the right foreground is the jail, erected in 1914. Diagonally across the intersection is the three-story home of the Logan family.

Downtown Scenes

VOLUNTEER FIRE DEPARTMENT
McGucken and Hiers of Tampa constructed this building in 1914 as the Polk County jail. It later housed the city's volunteer fire department.

101 Glimpses of Historic Bartow

Paving Mule
When this was taken in 1918, this mule had already worked twenty-one years for the city, paving streets initially with clay and later with asphalt.

Downtown Scenes

CITY HALL
To replace the old city hall on the second floor of the firehouse, this structure was built in 1915. Designed by Howard & Wread, it cost $17,500.

HOSPITAL FOR INDIGENTS AND BLACKS
Polk County was one of the first counties with a hospital to care for indigents. Constructed in 1926, the hospital was staffed by one doctor and five nurses.

Downtown Scenes

Bartow Memorial Hospital
This facility opened on March 1, 1928, at 1239 East Main Street. It was expanded in the late 1950s with the addition of a home for its nurses.

Boy Scout Hut

During the 1930s, the Public Works Administration built several projects in the area. One was this building for Bartow's Boy Scouts. It is no longer standing.

Downtown Scenes

Civic Center
Built of fieldstone in 1935, this Federal Emergency Relief Administration (FERA) project served as a banquet and meeting room and performance hall until it was replaced in 1967.

Masonic Lodge
When it was built in the 1880s, the taller building shown here had the lodge meeting room upstairs and an open-air meat and produce market downstairs.

Downtown Scenes

FIRST AIRMAIL FLIGHT
This enthusiastic crowd gathered on May 19, 1938, to celebrate the first official airmail flight departing Bartow for Lakeland.

BARTOW ATHLETIC FIELD
This sports facility was completed in 1939 as a public works program. It resembled many other Florida projects of the 1930s with its fieldstone walls.

Downtown Scenes

First Public Swimming Pool
From the mid-1930s until 1967, this was the public pool. A public works project, it also included a bathhouse, playground and picnic area.

101 Glimpses of Historic Bartow

Post Office
Bartow's first official post office opened in 1869, with Robert Wilkerson as its postmaster. The federal government called it Peas or Peace Creek until 1879.

Downtown Scenes

Fort Blount Marker
In 1947, the Daughters of the American Revolution (DAR) dedicated this marker at the site of Fort Blount. It was unveiled at the corner of West Main Street and Floral Avenue.

FIRE DEPARTMENT
The fire department formed in 1887, reorganized in 1913 and initially shared a building with the city hall. It then occupied this firehouse until 1966.

Downtown Scenes

Bartow Air Force Base
The municipal airport served as a pilot training base during World War II, and again from 1950 until just after this photo was taken in 1961.

BARTOW MUNICIPAL AIRPORT
With the permission of the Federal Aviation Administration (FAA), a portion of the airport was turned into an industrial park in the mid-1960s. It is pictured here during a 1973 fire.

Historical and Genealogical Library
Before it moved into the former courthouse, the library occupied this home at 495 North Hendry Avenue. The house was torn down in 2002.

101 Glimpses of Historic Bartow

Businesses

HUGHES STORE
David Hughes moved to Bartow in 1868, built a house and entered the cattle business. He opened a store in the tallest building shown here in 1870.

LAND OFFICE AND LANG BROTHERS STORE
The land office (left) was built by Dr. A.B. Brookins in 1882 to serve as a drugstore. The tall building in the middle was the Lang Brothers store.

Businesses

Advance-Courier Building
The second building from the left housed the *Advance-Courier*, a newspaper founded in 1887. It was owned by B.B. Tatum and G.M. Holder.

DELIVERY OF SAFE
Shown here is a team of oxen pulling the cart carrying a new safe to the Polk County Bank in 1886. The wheels ran on temporary railroad tracks.

Lightsey and Lewis Livery Stable
This livery stable was operated in the 1890s by W.H. Lewis, U.A. Lightsey and A.J. Lewis. They sold it in 1907 to T.G. Lockwood.

Cheatham and Jones Livery Stable
This was formerly the stable of Lightsey and Lewis, expanded by the addition of twenty stalls and acquired by Messrs. Cheatham and Jones.

BUSINESSES

DIXIE THEATER
Also known as the Opera House, this theater was built in 1907 and was owned by T.L. Marquis. It stood at the corner of Main Street and Central Avenue.

Fort Meade Garage

Walter P. Crutchfield Sr. founded this auto repair business in 1914. He is shown here as a passenger in a car driven by W.A. Dopp.

Businesses

Overbay Livery Stable
This business of P.E. Overbay was located at Summerlin Street and Florida Avenue, across from the W.Z. Overbay feed and seed store.

Wilson Hardware Store

"Uncle Charlie" Wilson is pictured here (seventh from the left) in 1915 in front of his C.L. Wilson Hardware store on North Broadway Avenue.

DAVIS CASH STORE
Standing in front of their store in 1918 are Thomas B., Hattie and Mary H. Davis. On the right is shoe salesman Jerre Crook.

LAKE GARFIELD NURSERIES COMPANY
This shipper of oranges and grapefruit used "Our Lake" as one of its brands. Pictured here in 1920 is one of its partners, R.L. Bryan.

Businesses

Coca-Cola Bottling Works
Bartow's thirst in 1922 was quenched by Coca-Cola from this bottling plant. The plant was managed by Lester Bruce, the man on the right.

101 Glimpses of Historic Bartow

Lake Garfield Citrus Growers Association
In 1915, Lake Garfield growers began producing the queen orange variety. Discovered near Bartow before 1900, it was found to be resistant to cold.

BUSINESSES

GARAGE AND RADIATOR SHOP
The 1920s influx of tourists in automobiles required people to repair them. Shown here are Welch and Whipple's Garage and Barabree's Radiator Shop.

WILSON DRUG COMPANY
Sam Wilson and Henry Blount opened a drugstore in 1894. It is still in business on East Main Street and looked like this in 1933.

BUSINESSES

OAK CITY GUANO COMPANY
This business made fertilizer from excrement. Its owner during the 1930s was James McEnroe, the man in knickers standing by the truck.

LOVETT'S GROCETERIA
Lovett's was originally located in the 1890 two-story masonry building that still stands at 125–135 South Central Avenue. It looked like this in 1910.

Businesses

Main Street
On the corner of Central Avenue and Main Street in the 1940s sat Florida National Bank. Next door, to the left, was the Wilson Drug Company.

FLORIDA NATIONAL BANK

George Garrard, the man standing in the center of this photo, was one of the customers of the Florida National Bank, shown here during the 1940s.

PHOSPHATE REDUCTION PLANT
The area's phosphate industry began in the early 1880s, when Peace River pebbles were collected. Later, land pebbles and hard rock were mined.

Phosphate Museum
The Phosphate Museum began in the 1950s in Bartow with exhibits on prehistory such as this one. The museum was later relocated to Mulberry.

Lodgings

WRIGHT HOUSE HOTEL
J.C. Wright erected this building at the corner of Wilson Avenue and Davidson Street in the 1880s. It was one of Bartow's most fashionable hotels.

Commercial Hotel
Captain David Hughes owned this building, with his store located downstairs. Upstairs was the Commercial Hotel, later known as the Central Hotel.

LODGINGS

LYLE HOUSE
This house on North Street was the home of Mr. and Mrs. William B. Lyle. He was known as one of the area's most progressive farmers of the 1890s.

ORANGE GROVE HOTEL
This was built in 1867 as Gideon Zipprer's home. It was later a hotel called the Bartow House, then the Blount House and finally the Orange Grove Hotel.

LODGINGS

TREMONT HOUSE HOTEL
The first building on the right in this view of Main Street was the St. Mark Hotel, built in 1882. It was later renamed the Tremont House Hotel.

Alexander House
This was the home of Dr. Ulysses A. Alexander and his wife, Helen Wilson Alexander. It stood at 930 South Oak Avenue.

Lodgings

Mitchell House
This was the home of Joseph L. Mitchell and his wife, Eula. He served as the superintendent of the Summerlin Institute.

Earnest House
Department store owner Charles E. Earnest built this three-story home in 1905. It was later torn down to make room for a church parking lot.

LODGINGS

WILSON HOUSE
Pictured here in 1910 are the Earnest house on the left and one built in 1908 by Allie F. Wilson. Wilson's house was later home to T.W. Gary and then Reginald Garrett.

Swearingen House

Will Swearingen was building this house when he died in 1912, so it became the home of his widow, Laura. It was the first in Bartow with central heating.

STEWART HOTEL

This was constructed in 1914 as the Stuart Building by E.C. Stuart. He rented it to N.E. Stewart, who operated it as the Stewart Hotel.

101 Glimpses of Historic Bartow

Davis House
Located at 395 North Broadway Avenue, this was the home of Thomas B. and Mary H. Davis. Daughter Mary Hattie sits atop the fence.

REED HOUSE
Charles E. Reed owned this home located at 72 Church Street. Playing in the yard in 1918 are his grandchildren, Ted and Betty Mack.

Law House
Built before 1900 by Ziba King, this home was purchased by General Evander Law. In the 1920s, it was acquired by the Bartow Women's Club.

BLANDING HOUSE

This was the home of A.H. Blanding, the army's youngest brigadier general to serve in World War I. Later, he was chief of the National Guard.

Varn House
Nicknamed "Tall Pines," this was the home of surveyor William B. Varn. He also served as Polk County's superintendent of schools.

LODGINGS

NEW OAKS HOTEL
The Oaks Hotel, also known as the Tourist Hotel, was built in 1907 to attract tourists. It was remodeled into the New Oaks Hotel during the 1920s.

CRYSTAL PALACE
Built in about 1885 by E.W. Codington, this house received its nickname because it was next door to the Crystal Ice Works. Later, the Mann family lived here.

LODGINGS

WONDER HOUSE
Conrad Schuck built this with rock found on the site. The house was cooled by pass-through breezes and rainwater caught in hollow porch columns.

101 Glimpses of Historic Bartow

Schools and Churches

SUMMERLIN INSTITUTE
Bartow's first public high school was named for benefactor Jacob Summerlin. Shown here in 1887 is the ceremonial setting of the school's cornerstone.

First Presbyterian Church
In 1882, this church was founded with six members. Shown here in 1887 is the newly completed sanctuary designed by M.M. Dunlope.

Schools and Churches

South Florida Military Institute Cadets
This school was founded in 1894 by Brigadier General Evander McIvor Law. Its two-story wooden building, shown here, was erected the following year.

Summerlin Institute
Summerlin Institute was the first brick school located south of Jacksonville. Pictured are some of its students in a daytime astronomy and surveying class.

Schools and Churches

Peace Creek Baptist Church
This church was founded in 1854 by eight individuals. The wooden sanctuary was built in the mid-1880s near what was then called Peace Creek.

Summerlin Institute Cadets

Cattle baron Jacob Summerlin built Bartow's first wood-frame school building in 1867. The city named it in his honor.

Schools and Churches

First Baptist Church
The Baptist congregation was formed in the 1870s and built this church as its second sanctuary in 1900. It was moved in 1924 to make room for another.

First Baptist Church
The neoclassical-style church was built for $60,000 in 1925. It replaced the first Baptist sanctuary, which had been dedicated on April 1, 1883.

Schools and Churches

Associate Reformed Presbyterian Church
This is Bartow's only neo-Gothic-style church building. It was completed in 1926 with stained-glass windows made by the Empire Glass Company.

School and City Auditorium
On the right is the two-story Bartow Elementary School. This 1929 photo shows the extension being built to connect it to the city auditorium.

Schools and Churches

First Methodist Church
Now the First United Methodist Church, this Richardsonian Romanesque-style sanctuary was built by Lonnie Tate in 1907 for $16,000.

First Christian Church
This sanctuary was ten years old when it was photographed in 1935. It replaced a previous church building erected in 1886.

SCHOOLS AND CHURCHES

FIRST BAPTIST CHURCH CHOIR
Shown here in 1938 is the First Baptist choir. They are assembled in the 1925 sanctuary designed by J.E. Green of Birmingham, Alabama.

Mt. Gilboa Baptist Church
Organized in 1893, Mt. Gilboa built its first sanctuary on this site in 1896. It was replaced with this 1928 stone church, photographed in 1944.

Schools and Churches

St. Thomas Aquinas Catholic Church
When photographed in the 1940s, this was the Catholic church. In 1956, the members relocated and this building was moved to Lake Buffon.

Peace Creek Baptist Church
This is a 1950 photo of the new building for the church, which served into the 1970s. This is the oldest Baptist congregation in Florida.

Schools and Churches

First Presbyterian Church
This congregation was founded in 1882, built a sanctuary in 1887 and replaced it with this building in 1932. It was enlarged and remodeled in the early 1960s.

101 Glimpses of Historic Bartow

Bibliography

Brown, Canter, Jr. *Florida's Peace River Frontier.* Orlando: University of Central Florida Press, 1991.

———. *In the Midst of All That Makes Life Worth Living: Polk County, Florida, to 1940.* Tallahassee, FL: Sentry Press, 2001.

Frisbee, Louise K. *Peace River Pioneers.* Miami: E.A. Seemann Publishing, Inc., 1974.

———. *Yesterday's Polk County.* Miami: E.A. Seemann Publishing, Inc., 1976.

Hetherington, M.F. *History of Polk County: Narrative and Biographical.* St. Augustine, FL: The Record Company, 1928.

McNeely, Ed, and Al R. McFadyen. *Century in the Sun: A History of Polk County.* Bartow, FL: Polk County Centennial Committee, 1961.

About the Author

Steve Rajtar grew up near Cleveland, Ohio, came to Florida to go to college and decided to stay. He has been involved with the Boy Scouts for over thirty years and is an activity leader for the Florida Trail Association. The combination of a love of the outdoors and local history has resulted in his setting up over 150 historical walking tours through Florida communities, including Bartow, which can be used to rediscover the region's historical sites.

Visit us at
www.historypress.net